T0169917

COVERT: A Handbook

30 Movement Meditations
for Resisting Invasion

by Melanie Kloetzel and Phil Smith

with photographs by Brooks Peterson

tp

Published in this first edition in 2021 by:

Triarchy Press
Axminster, UK
www.triarchypress.net

ISBNs:
Print: 978-1-913743-15-4
ePub: 978-1-913743-16-1
PDF: 978-1-913743-17-8

Photographs by Brooks Peterson ~ brookspeterson.com
(except photos on pp. 25, 41, 61, 73, 81 and 90 by Melanie Kloetzel)

Printed by TJ Books Limited, Padstow, Cornwall

We would like express our gratitude to photographer Brooks Peterson, photo subjects Alén Martel, Cindy Ansah, Stephanie Jurkova, and Laura Hynes, as well as all those who have participated and given us feedback on the Covert process through various workshops, visits and lessons.

Contents

Introduction

Do you ever feel that you are on a runaway train with no station stops? That you're hurtling along with no time to pause or ask important questions? That you live in a world where people regard your online presence as more important than your physical one? Have you ever felt lonely or just unsettled and then caught yourself scrambling for a cell phone or a tablet to ease that feeling? And have you noticed that satisfying such frantic urges with screen time doesn't really make anything better? Rather, it just reinforces the sense that you've shared your feelings with an indifferent, faceless machine?

We are not the first generation to experience loneliness or a sense of alienation from others and the world. But what is different this time is that our isolation and unhappiness emerge not from distance or separation, but from intimacy, not by closing down but by opening up. The monster that generates our dependence is not a bully or a dictator, but our digitized friend. Though its servers may be built and managed by huge corporations, the digital machine is fuelled, maintained and sustained by us. We are both the producers and consumers of this monster. By

feeding it with our posts, sharing with it the most thoughtful, emotional, and personal parts of ourselves, we are the ones allowing it to claim greater and greater intimacy. Instead of cherishing and cultivating our feelings and contemplations, we deliberately turn ourselves inside out for the machine.

Covert is a reminder that, despite all that, we have more control than we think. It reminds us that our whims and hopes, concerns and inspirations can be appreciated, treasured, protected and cultivated. Further, *Covert* prompts us to carve out the time and space to nurture that inner life, and it warns us that if we don't actively nourish and protect it, we will lose it.

In short, *Covert* offers a constructive path for defending and preserving ways of being in the everyday world that do not leave us under constant scrutiny. As a handbook, *Covert* advances a method for sidestepping or evading invasive gazes, gazes that want to know not only our purchase patterns, but also our hopes and fears, preferences and pursuits. And it does so through a highly practical process that both respects and enriches us as grounded, multidimensional beings.

To do this, *Covert* prioritizes the *body*. It highlights the body's role in our most private contemplations as well as the part the body can play in nurturing and protecting our inner creativity – insights, visions, musings and epiphanies – as they emerge from dreams and imagination into consciousness. It firmly welcomes and embraces all bodies – in whatever shape, form or ability – as the key means through which we can know both the world and ourselves. Starting from the premise that our bodies are the medium of our feelings and thoughts, this book suggests ways for us to re-integrate ourselves – emotions, ideas, fantasies, muscles, memories, bones,

actions, organs, dreams – with the *non*-virtual world that surrounds and embraces us.

At its simplest, *Covert* is a collection of 'movement meditations', straightforward and basic physical activities that aid inner reflection. Using its exercises –done with your fingertips or your whole body, for two seconds, two minutes or two hours – *Covert* offers the means to seek out present, pleasurable and complex experiences that resist being reduced to a pixelated pattern or to a hashtag that gets a 'like' from a Facebook friend.

Ultimately, *Covert* proposes a way to embrace our multiplicitous and connected selves, not as separate *from*, but as *part of*, the physical world that surrounds us. Joining movement, contemplative practice and the richness of place, the *Covert* process aims to uncover the means to withstand, and perhaps even defy, efforts to devalue the fullness of human experience. And, in defending what we are losing of ourselves, we may learn something about how we create those *selves* in the first place.

Invasion and the Self

In an article in the Winter 2016 issue of *ROAR* Magazine, Alfie Bown asked "what if our digital footprints, besides *revealing* our desires, are also responsible for the very *construction* of these desires?"

We have all had the experience: wondering how an ad for winter boots or sunglasses or shampoo pops up on our email sidebar after doing a search for the same item on a different device. Indeed, we are now so used to such occurrences that we rarely remark on or even notice them anymore. As digital algorithms seek deeper and deeper

access to our preferences and predilections, discovering ever more ways of looping the findings back at us across multiple platforms, we surrender to their reach. Through our ever-present handheld devices, we offer up our psyches like a candy store to the retailers and information moguls alike.

But what is it that these algorithms ultimately seek? Besides the obvious – our wallets – there is a deeper penetration at work. As Mark Zuckerberg has declared, algorithms for social media mechanisms are not only or merely invested in acquiring money; rather, they are delving for "a fundamental mathematical law underlying human social relationships that governs the balance of who and what we all care about". Those who create and employ the algorithms believe they can penetrate and systematically put to use our deepest fears, loves, aspirations and needs, seemingly without shame or hesitation.

And they are increasingly successful in their endeavours. Their invasion of our inner selves is a brutal affair, through which we are 'set apart', made quantifiable, generic, isolated and reproducible. This setting apart from ourselves and from each other takes different forms of intensity, depending on whether we are, say, refugees misrepresented on propaganda posters or privileged homeowners steeped in social status and education. Tailored to our social or cultural placement, the algorithms seek to make us all victims of various kinds of 'imposter syndrome' by tricking us into identifying with a reduced (or unduly inflated) image of self. This carefully crafted self-image, which is measured, categorized, delimited and re-calibrated with cool efficiency for the algorithm's benefit, can make us uncertain or suspicious of (or maybe even dissatisfied by) our real selves.

Yet our analysis of this social assault needs to go deeper still. For beyond the penetration into our emotional and imaginative treasures, the invasion is now so deep that it endangers something less obviously precious, less present, less real. It threatens the very *possibility* of hiddenness within ourselves. As the algorithmic infiltration expands, insinuating itself into (and beyond) all thought and action, it threatens that profoundly personal nexus where our hidden hopes and desires tentatively emerge from our unconscious mind. In its merciless effort to slip past our deliberate decision-making into the deepest corners of our being, it menaces that sanctuary, that vital space for creativity and imagination, where the ineffable meets, and reveals itself to, the conscious mind.

It even threatens our dreaming.

For obvious reasons, it is not easy to describe the hidden and unconscious part of the self. Psychologist Josh Cohen has identified it as an inner life that "depend[s] on keeping public and private rigorously distinct... the distinction between things that should be shown and things that should be hidden." This hidden part of the self, according to Cohen and others, functions in a space disconnected from the world of symbols, images and signs. It precedes visualization, schemes and fantasies. It is the *raw* part of the self before choice or consciousness emerges.

Another way of conceiving of this raw self is as a kind of *quantum signature*. This quantum signature, biotic in nature, has developed over time and in touch with the biophysical world. Mysterious and slippery, it exists in a wonderfully 'undefined' state; indeed, its lack of definition and its unpredictability is its point. In this raw state, it can figure for us as a *potentiality* (in the same way that a photon

can exist *potentially* as both particle <u>and</u> wave). The potentiality simmers, ripens, cavorts (or whatever verb makes sense for an unknowable process!) in our unconscious; yet, once seen or ensnared, the potentiality crystallizes, collapsing into a fixed idea or intention.

While the collapse of our quantum signature is inevitable in the transition from unconscious to conscious mind, if we rush this process, we cheat ourselves of our full creative capacity. In other words, we have only a precious and often brief time when we can experience that potentiality before it collapses into an objective something: an idea, data, a preference or a poem. The longer we can sustain that time of emergence, the more likely it is for the collapse to be complex, creative and generative, rather than predictable,

obedient and routine. But, as we spend more and more time in communication with the virtual world, the process by which this signature coalesces or collapses is shortened, hampered and pinned down. Instead of emerging from its pre-defined state in as safe and productive manner as possible, the algorithmic incursion grants less and less time for this valuable process.

All this is chilling. While invasive algorithms – like our own *conscious* selves – cannot (yet) forcefully extract information from our raw unconscious, they can disrupt it, shining a light or casting a gaze into it, and, at the earliest opportunity, collapsing its potentiality into the quantifiable banalities of the algorithmic world. Through such disruption, they threaten its space of emergence and, in so doing, either fix our thoughts into dull simulacra of promising ideas or drive the raw unconscious self back into hiding until we begin to lose all sense of it, or, worse, deny we ever had it.

If it helps, imagine this process as something like an eel nervously emerging from a crevice or like the soft parts of a crustacean or mollusc creeping out from a protective shell or exoskeleton. At times, this delicate and skittish entity might emerge roaring or raging; more often, this emergence will be tentative and quiet. Whichever it is, we must attend to it carefully, protectively, letting it grow as it wishes in this tender stage.

Covert is about protecting and developing this process of emergence, whereby a conscious self emerges from the unconscious. In short, through a series of place-based movement meditations, this handbook offers a way for the *emerging self* to unfurl in a sheltered way, seeping into spaces of hidden potential throughout our bodies and connecting our inner selves with the wider world. Instead of letting invasive algorithms empty and capture our interior spaces for their own purposes, the *Covert* method

allows and encourages us to safely *re*-permeate such spaces for our own elusive inner dance, cultivating the 'wiggle room' necessary for a more intuitive life *and* a more imaginative *self* – what the writer Franco 'Bifo' Berardi calls "poetry passing through flesh".

To discover this poetry, the practice outlined in this volume emphasizes two key actions: *one*, intensely connecting to the wider (non-virtual) world, and, *two*, being physical.

For the first step, past the obvious one of tearing yourself away from the screen, *Covert* urges you to move beyond the private spaces of home and into the public sphere, finding spaces that offer room for engagement – physical, emotional, psychological, intellectual. You won't necessarily need to go far. The movement meditations outlined here encourage you to walk through quiet city streets or alleys, or frequent the parks or rural spaces near your home; they may even encourage you to stroll down busy public thoroughfares or into local markets. As we will outline in greater detail in the following section, what is critical about this exploration is to identify those spaces that can aid in nurturing your inner life. Believe it or not, all around you are spaces with special affordances, spaces that provide a kind of embryonic and auspicious sanctuary. Once you learn how to spot them, you can map a protective arena, one that offers your emerging self the room to expand.

The second critical element is *movement*. The movement meditations detailed below reveal the *physical* and *active* dimension of our inner selves. Refusing the outdated concept of separating mind and body, of privileging thought *over* world as in 'positive thinking' models, the *Covert* practice emphasizes how introspection, contemplation, even daydreaming finds a fuller realization when woven with physical actions in a physical world.

Though this may seem like an odd direction for a meditative practice, through being physically active we can learn to intensify and nurture our awareness, providing our emerging self with both the space and sustenance for further development.

But while the practice may sound a bit like an art form or maybe a training method, the most important thing to know is that, however it is categorized, it is a *subtle* practice, and fundamentally *not* one that is about creating a spectacle or performing in any way. *Covert* encourages you to nurture a physicality that flies *under* the radar. Through simple pedestrian movements enacted with a contemplative focus, you can test the edges of behaviour; you can find ways to move without attracting unwanted attention, cultivating and cherishing the dance that develops between your emerging self and the environment.

That said, simple does not always mean easy, and it may take you a little time. You will need to be ready to experiment and even, periodically, ride the rollercoaster of frustration, distraction and perhaps weariness, as you learn to foster and attend to your emerging self.

So, enough theory, let's get down to describing the practice. Over the following pages, we will outline a step-by-step guide to joining inner reflection with both subtle physical play and public space (natural and/or developed). Specifically, we will take you through the steps to:

1) identify likely places to perform the movement meditations

2) enact protective measures for yourself (and, perhaps, a partner) as you experiment with the meditations in public space

3) execute the individual steps for each meditation

4) create a sequence of meditations for a fuller practice.

One additional note: while the movement meditations detailed here may certainly be practiced by you alone with positive impacts, we have found that for some of the best results, it has been helpful to find a friend who is ready to embark on this journey with you. We'll describe this partner experience in further detail below, but either alone or together, the first step is to engage with place.

Welcoming Spaces

Our own starting point for *Covert* was a recognition that some spaces, often quite odd in nature, had a certain enchantment, and that, despite their oddness, these spaces had something in common. They seemed to be a bit overlooked, a bit disregarded – as if somehow unwilling to be seen. They too seemed to want to fly under the radar, perhaps to cultivate their own emerging selves.

Some of these spaces were disused, like a small city park left to be taken over by weeds or decay. Some contained obvious humour, like a stairway that leads to a blocked entrance. Often, they were places where something had gone missing and never been replaced, or an object had lost its purpose – like a bench that had disappeared but left its legs, or a gate that was no longer attached to a fence. Sometimes they hid in plain sight; other times, they hid behind high walls or in an overgrown edifice. Sometimes the spaces were layered and ironic, like a suburban garden with reproductions of 'classical' sculptures (with the sculptures themselves echoing the Renaissance replicas of classical antiquity). Sometimes they were spaces where two incongruous vistas could be seen simultaneously. Sometimes natural beings added a certain eccentricity to a space – a tree growing on a slant, or a scatter of rocks or a grove of trees that seemed utterly out of place in a city centre.

We began to notice that these spaces did not 'perform' in quite the way they were intended to, as if they wanted to resist their apparent purpose or meaning. Rejecting the obvious, these spaces offered a subdued or even subversive energy to tap into, an energy that beckoned to our own mysteries, inviting us into dialogue or interaction. We joked that these were places that were unlikely to appear on anyone's Facebook feed. Instead, they seemed to encourage a reflective or private presence, spaces where certain activities could be attempted just beyond the radar of surveillance. These spaces gave us *room* to experiment without attracting undue attention. Eventually we began to call them 'affordant spaces', spaces that allowed or *afforded* us the chance to play (or just *be*) in a contemplative manner. After experimenting in a number of such spaces, we discovered that these affordant spaces – some quiet, some busy or even noisy – were ones where you could get away with subtle experiments that, in other circumstances, might attract a fearful or angry look or bring the security guards running.

As part of this practice, you will need to start identifying such affordant spaces. We are painfully aware that, due to societal biases and constraints, this affordance will vary according to who you are and how you appear, as well as who may patrol or 'own' public spaces (or think they do). It is critical to be mindful of concepts of privilege (whether based on class, gender, race or sexuality) as you uncover such constraints, protecting yourself (and your friend or practice partner) in the process; in short, be mindful that any ability you may have to pass under the radar may not be available to everyone and that many of us may need to seek more intently or across a wider area to find such affordance.

To help you through the identification process, many of the environmental movement meditations or 'scores' (as we describe in the next section) are named for the type of place where the meditation could occur. Thus, we offer titles such as a 'Score for an abandoned playground' or a 'Score for a blocked doorway', as a way to help you more quickly detect affordant spaces.

This is merely a shorthand, however. We are aware that one abandoned playground may be very different from another; one may be affordant and another not. Thus, you cannot rely on these generalized titles (or generic identities) *alone*; you will need to detect the affordances available in your particular place, adapting the scores to your circumstances. As Melanie has pointed out in some recent articles about adaptation and site (see end bibliography), it can be helpful to be aware of similarities between places even across vast distances; but each place is also unique due to a larger context that frames it, so try to address each place with the individual care it requires. If you do so, you may find that even places that seem 'generic' at first reading can support your quest for a healthy emerging self!

To discover the affordant spaces in your area, the only requirement is to observe. Put up your antennae and watch for the signals that indicate the presence of an affordant space. Sense the idiosyncrasies of that place. Notice who is in the space, and who isn't. Notice if people are avoiding the place, and, naturally, if there are any surveillance cameras. Notice where people pause and where they hurry past. And, in particular, notice if there are pockets in the space that seem to be overlooked or unseen, for it is often the places where things are slightly neglected or askew — or where a collection of 'unattractive' elements resides — that may be the most affordant for our purposes. At times, it helps to have a bit

of knowledge about a place, some sense of its history; but mostly you just need to look with a careful eye and feel for a certain atmosphere. If you want to chase down ideas that can help inform your sensitivity to the agency of places and materials, look at Jane Bennett's book *Vibrant Matter* or Karen Barad's *Meeting the Universe Halfway*.

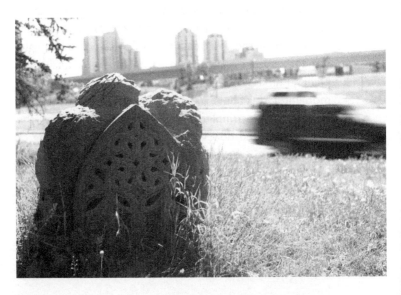

We have found that some affordant qualities are present even in large, very open or busy spaces; so, for example, we have danced unseen and unnoticed around a monument in a public park, or found ourselves at ease doing the meditation scores in a large covered and chaotic market building, finding particular spots where official gazes seem to touch lightly or just pass over. In such places, we discovered that we could slip in and dwell for a while, moving to our hearts' content. Conversely, we also found that some apparently inviting spaces were *not* conducive to movement meditations; a quiet, seemingly sleepy alley jolted into high alert, filling with

concerned residents and a police officer after a mere moment of unusual waiting and walking. The key thing was not whether a place provided physical or architectural *cover* for experimentation, but rather whether its ambience and context offered a hidden invitation to a meditative mover.

Another note: You may find that you need to adopt a particular 'frame of mind' to engage in this process of identifying affordant spaces. This frame of mind may be sharper than the everyday level of attention you might use for routine travel or tasks. In his book *Enchanted Things*, Phil describes this heightened mode: "I stop for a moment. I look about me. Something slightly 'off' catches my eye: an incomplete sign that teeters toward the absurd, a rusted doorway that triggers a rare feeling of conviction, a tree shaped like a pinball machine, the remains of a windscreen glittering like emeralds, a fence just a little too bright for a barrier, a toy bigger than it ought to be." In short, let yourself experiment with this frame of mind, so that you might detect the affordant places or objects in your area that best facilitate your *Covert* journey.

The Process

To begin the *Covert* process, set aside some *time*. Time without a purpose or a target. Initially, this may take longer than you imagine, an hour or two that can allow you to carefully familiarize yourself with the steps of the process. But as you grow accustomed to it, you may be able to identify affordant spaces quickly, dropping into them and indulging in five or ten minutes of inner cultivation as you move through your day.

The main ingredient of the *Covert* process involves enacting what we call 'scores' in particular places. A common tool in many creative and improvisational circles (in dance, music and theatre, for instance), a 'score' is, in the most basic terms, a series of steps to follow or actions to complete. Yet, a score is not definitively fixed or set; it offers room for each individual to experiment within the parameters of a given step. For our purposes, the scores listed below consist of very basic movements – sitting, standing, walking, leaning and the like – that typically go unnoticed in public spaces and that you can adjust and enact as you see fit.

As you begin to experiment with these scores, let your gaze be soft. If in a busy place, allow it to just drift by other people in the space; avoid making eye contact. By avoiding the gaze, you can relish the subtlety of both your environment and your own movement, exploring what it means to move in unusual ways in public spaces *without* creating a spectacle. For some scores, where it feels quite important to look in a particular direction or take in details about your environment, just remember that this endeavour is about a dialogue between the physical world and your emerging self, not about developing interactions with passers-by. Through experience, and by trial and error, you will begin to identify the best spaces and best methods for enacting the scores without attracting attention.

As noted earlier, working with a partner can be beneficial for the *Covert* process. Identifying welcoming spaces together and supporting one another when doing the 'scores' can be very helpful, particularly in the early stages of this process. A partner can act as a 'guardian' for your meditations. You and your friend will each get a chance to enact the scores, but each of you will also help facilitate your partner's meditations, gaining a deeper

understanding of how such welcoming spaces function. Notably, this support can (and actually should) be done in a physically distant way, not compromising either partner's health during a pandemic. (To be clear, we encourage you to follow the best scientific advice concerning physical distancing during a pandemic for both your own and your *Covert* partner's safety as well as for the community in general).

Typically, a guardian will need to do very little – simply offer a peripheral moral support to the mover's meditative experience. But guardians may also draw any unwanted attention away from a meditating partner. This can usually be done quite subtly, by moving across the gaze of an onlooker in order to redirect their focus. At times, you may need to offer a slight nod or small greeting to distract a passer-by from your partner's activities; at other times, you might be able to move in a way that helps to 'disguise' the score being enacted by your partner. As guardian, if your efforts to 'hold ground' for your partner do not work (i.e. people – official or otherwise – are starting to focus more forcefully on your partner), be prepared to gently interrupt your partner's exploration and move them away from the space. Both partners should work to avoid (or deflect) any potentially malevolent gazes, whether from CCTV cameras or passers-by.

For the mover, revel in the support that your partner offers and use it to bolster your movement meditation. Sense the extra level of protection and take pleasure in the opportunity to expand your practice.

And now – either with or without a partner – let's move on to the steps of the *Covert* process...

a/ Identifying Affordant Spaces

Choose a particular area of your local environs to explore. As you (and your partner) walk through this area (neighbourhood, city park, market, etc.), look out for a likely space that might be a bit 'set aside', or that seems to suggest a degree of 'hiddenness in plain sight'. Note the level of surveillance, the demeanour of the passers-by, and check other people's reactions if you pause momentarily. Remember, for the space to be affordant, there needs to be, at most, a minimal level of surveillance (preferably absent) and very little potential for reactions by, or interactions with, others.

In your first *Covert* journeys, you may need to keep this text at hand in order to consider which of the movement meditations might suit the quirky elements in your area. Allow the cues from the meditation titles to help you in the identification process. Are there trees growing at a slant? Are there blocked doorways or hidden crossroads or distant vistas to experiment with? Are there public monuments, sculptures or, perhaps, missing objects or gaps that are suggestive? Consider how you might enact one of the scores at that particular site: which score might work well with the site? Which might be applied with relative ease? How can the score be adapted or tailored to the site? Try out a brief version of the score to check its suitability before you move on to the next step.

b/ Doing the Scores

Once you have identified an affordant space that meshes well with a particular score, enact the score more fully. In other words, do the steps of the score. Don't worry about how 'well' you do each step; just let the simplicity of the movements guide you, integrating your physicality with the place you have chosen. Feel free to revel in the relationships created between your body and the details of that affordant space. As you perform the steps, allow yourself to be quiet, to slip away from the social and into the contemplative; if with a partner, let them act as your intermediary, deflecting other people's gazes if they linger on you. Be sure to reverse roles so that each of you has a turn with the score and a turn as guardian. Consider how well the score is working for you. Do the physical details of the score suit your body, or do they need to be modified slightly to help your process? As you enact the score, feel free to make any subtle changes that seem necessary to facilitate your engagement with the place.

c/ Paying attention and looking away

As you experiment with the score, notice any associations
that surface or crop up, particularly if they seem to 'pop
up from nowhere'. Embrace the connotations of these
pop-ups, or enjoy their lack of logic! If these associations
take the form of a narrative then go with it, play a part in
it, but only for yourself, for your own protected process
of emergence. If you glimpse a vision (perhaps future,
perhaps past), allow that vision to unfold in whatever way
it chooses; you may want to flesh it out in your mind, or
perhaps experiment with it, but you may also just want to
enjoy its flickering image. If you sense a particular
atmosphere, immerse yourself in it; see if you can play with
it, gently shifting or modulating it. As you allow your
emerging self to stretch and awaken, allow new narratives
or logics to emerge. This is how you can feed your
emerging self, letting it gain in power and dynamism as you
explore, all the while protecting its gradual entrance into
your consciousness.

It is also important to avoid *too* much direction of your
inner thoughts. Don't try to force or express anything. Just
'do' the scores and let whatever arises through the
movement meditation emerge in its own way and own
time. If nothing comes, so be it. Walk away or give it
another go. But don't go digging for it. What will come,
will come; you are not seeking a 'correct' feeling or a
preconceived inspiration. You may find this unexpectedly
hard work; but stick with it. Some of the most conducive
or incisive moments come from unpromising beginnings.

d/ Making a Map

After you get the hang of identifying affordant areas and the link between scores and sites, it can be useful to create a collection of spaces in an area to make a 'map'. To do this, continue to wander through your chosen area and, by repeating steps a-c above, you (and your partner) can identify three or four likely spots for experimenting with particular scores. This way you can make an 'itinerary', a plan for which scores could fit into which spots and what order might work to enact the scores. If you are working with a partner, discuss the itinerary with them, noting how and where the role of guardian might be played by each partner along the route. Then set aside some time to try out the map, enacting a score at each spot along your itinerary. Take whatever time you need – 2 minutes, 20 minutes or longer – to allow your emerging self the time to unfurl.

e/ Repeating the Scores

Use the scores or your created map as often as you like. Remember, the scores are not 'things-in-themselves' (they are not a performance, or a discipline like Tai Chi). They are there as a scaffolding to nurture your emerging self in relation to your surroundings, to re-empower your inner rawness despite the encroachment of invasive gazes. You may even find that individual scores or maps continue to offer resonance when you visit a site for other reasons. But only use them for as long as they are *useful* to you; there are many places to explore, many scores to experiment with, and many potential maps to make, each of which offers new possibilities and directions for nurturing your emerging self.

So, open your front door, step outside and get ready to discover the hidden worlds around and inside you!

The Meditations

What follows are thirty place-based movement meditations or 'scores': basic step-by-step suggestions for moving your body in affordant spaces.

The scores are a *guide*; they do not need to be executed in an exact or 'accurate' way. The expansiveness or *scale* of the movement – large or small – may be (and, indeed, should be) partly determined by the spaces themselves. The key is just to try out the scores and determine your own comfort level and the scale of activity based on you and the individual space. As you begin to experiment, allow any thoughts and feelings to bubble up as they will. Let a dialogue develop between your moving body and the place; allow any hopes, desires or fantasies that want to appear, to flow through you. Most importantly, let the movement meditation imbue you with a sense of the hidden and generative process at work within you.

Finally, as you try out the scores, you may find that many are suited for solo enactment. But we would also like to add that *all* can benefit from working as a duo. In most situations, this will mean switching between the guardian and mover roles. But for other situations, the space may be affordant enough to allow both partners to participate simultaneously as movers in the score. As such, we have marked certain scores for use as a duo.

1/

Score for a strong leaning tree

1) Find a strong tree, one whose trunk leans appreciably to one side.

2) First, rest your full weight onto the leaning tree trunk (lay the front or back of your torso on the trunk); let it support you as you lean with and on it.

3) Then switch to the other side of the tree and press your back, shoulder or arms under and into the slanted trunk, as if you were supporting the tree's weight.

4) On either side, put your ear to the bark and listen to its language.

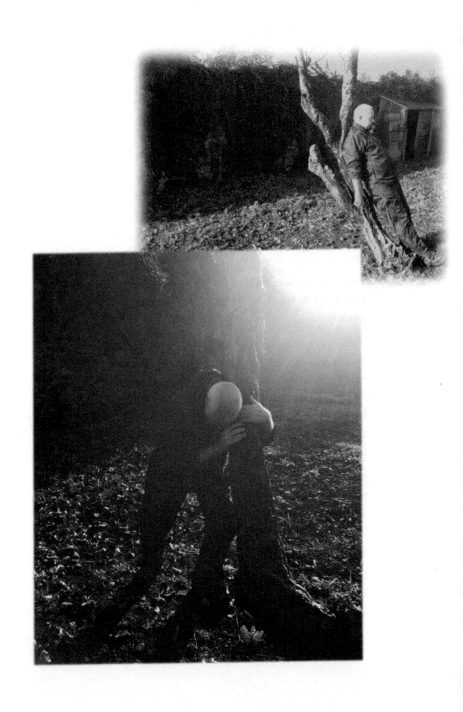

2/

Score for a place with near and far vistas

1) Find a low fence, wall, railing or something similar that you can touch while looking to a distant vista beyond it.

2) Stand very close to the fence, wall or railing and very slowly and carefully feel its surfaces with your hands and fingers. Take in the texture, temperature, surface inconsistencies, grain, and so on, purely by way of touch. Feel free to gradually inch your way along this surface as necessary.

3) While you are paying close attention to the information coming through your fingertips, allow your gaze to gently move to the distant parts of the vista. Shift the focus of your attention back and forth between the sensations of your hands and the sensations coming from the distance.

4) Once you can move freely between the two, between touch and gaze, try to pay attention to them simultaneously and equally.

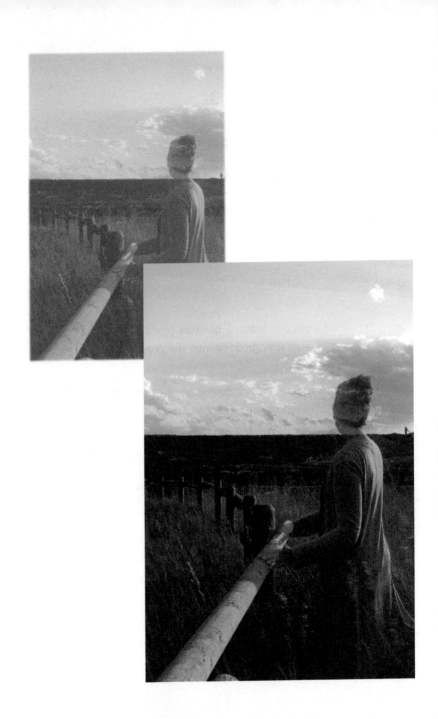

3/

Score for an embedded circular feature

1) Find a circular feature, perhaps made of brick or stone, that is embedded into the ground and can be walked on.

2) Walk around this circle repeatedly and with determination, as if you are traveling to arrive at a distinct, perhaps distant, destination.

3) At a key moment in your journey, pause and notice a significant spot across the circle.

4) Cut across to that spot and enjoy your arrival.

5) Then continue on your vital journey.

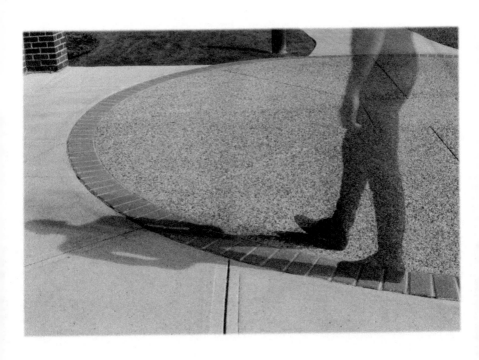

4/

Score for a missing object

1) Find a place from which an object has obviously gone missing (signalled by a gaping hole, an empty bracket, an impression on a surface that has not faded, etc.).

2) Consider the disappeared object, its size, facing, and function.

3) Put yourself 'in place of' the missing object. Re-enact its physicality and purpose.

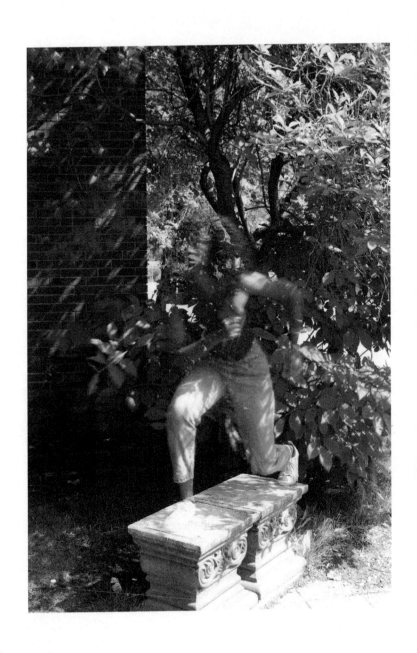

5/

Score for a small crossroads

1) Find a place where two paths make a crossroads. This might be at a junction in a market or where pedestrian thoroughfares cross in a city. It might be on a university campus, in a shopping mall or in a park.

2) Stand at the crossroads. Choose your orientation as if at an actual, and extremely crucial, crossroads (or turning point) in your own life. Don't set off down the chosen route; rather, once you have committed to a particular route, pause to connect to that choice, then walk away.

3) Return to the crossroads, this time orientating yourself in a different direction, with another set of life choices. Continue returning to the crossroads, each time changing the direction you are facing, calmly considering each option. Enjoy the multiplicity of your life; maybe struggle with it.

6/

Score for a grove of trees
(Possible duo)

1) Find a small grove of trees, perhaps in a city park, on the grounds of a hospital, anywhere.

2) Imagine those trees are holding a meeting. Find your own place among them to stand and join the meeting. (If the space supports it – i.e. there are no gazes to deflect – feel free to have both partners join the meeting.)

3) Listen to the discussion and imagine (maybe whisper) your own contribution to it.

4) If the meeting sways in the wind, sway with it.

7/

Score for a wall with horizontal layers

1) Find a tall wall that is composed of different layers. These may be simply the layers of bricks and mortar, or maybe something more complicated with different building materials.

2) Standing close to the wall, gradually bend your knees and feel yourself descending through the various layers.

3) Repeat, but this time focus inwards and imagine that you are descending through the layers of your own body, from your skin to your internal organs, to the raw self within.

4) After each physical descent, gradually rise up again. As you do so, allow your awareness to extend out from those internal layers to your skin and, finally, to the larger world beyond.

8/

Score for an abandoned playground

1) Find a damaged or abandoned playground.

2) Calmly explore the space and imagine the rusting and rundown equipment as beings of profound wisdom. (We found this was particularly effective with playground animals.)

3) Watch them, touch them. Listen to and care for them. Find your place in the playground of good ideas.

9/

Score for a shallow hollow

1) Find a peaceful meadow or a grassy area in a park where a shallow, human-sized hollow or depression has appeared. This may be on the centre of a traffic roundabout, in a former graveyard, on your own lawn, or on an empty sports field.

2) Check the hollow for anything you wouldn't want to lie in or on. Then, settle on your back into the hollow. Look up to the sky. Experiment with how to place your arms and hands.

3) Gradually try out different body positions, perhaps lying on your side or front as well.

4) Sense the giant parabolic sky and feel the earth that surrounds and supports you.

5) In your inner self, sink down and then rise up. Close your eyes and daydream your body as earth, your body as air, your body as sky, your body as stars.

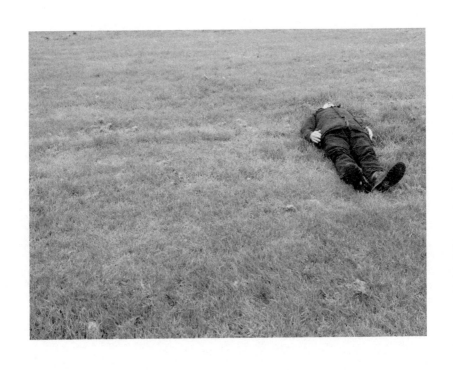

10/

Score for a blocked doorway
(Possible duo)

1) Find a doorway that has been bricked in or closed off.

2) Approach and then try to pass through the impossible portal in different ways. If the space allows, do this with your partner, with each of you taking turns approaching the doorway.

3) Imagine a different scenario each time you move towards the doorway. Consider knocking and expecting an answer, or cozying up to it; perhaps it is a sudden barrier to an important goal or a meeting point where you must wait for a friend.

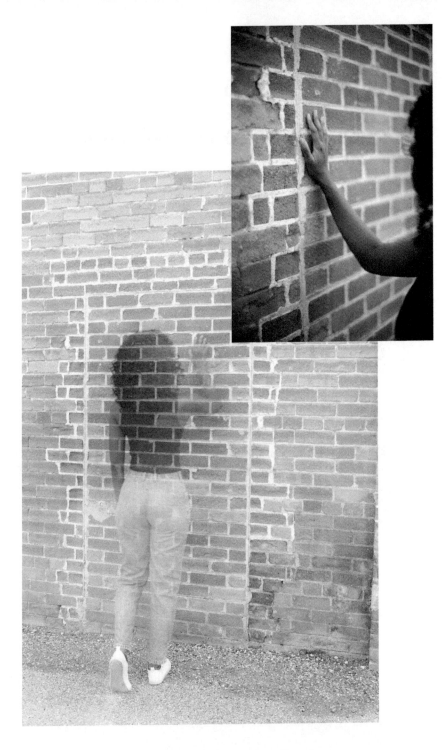

11/

Score for a busy gridded space

1) Find a public area that is dependent on a grid, such as a parking lot, a supermarket with its aisles of shelves and freezers, or a market with its stalls.

2) Move in ways that do not draw attention, but that resist the orderliness of the grid. For example, move in subtle spirals, curves, or angles that work against the grid; perhaps (if appropriate) softly bump into or gently bounce off its stable surfaces.

3) Consider the possibilities that reside in a gentle resistance, a careful refusal.

12/

Score for distinct side-by-side objects

1) Find two contrasting objects sitting side-by-side, ones that are made up of different materials. Make sure that both are stable enough to take your weight if you lean on them. These pairs might be a brick wall and a large stone, a litter bin and a bench, or a grassy bank and a cement base.

2) First, examine the surfaces; touch them carefully and consider their texture, temperature, colours, and any idiosyncrasies.

3) Then, place one hand on each surface and slowly allow your hands to take your weight. Shift your weight from one hand to the other. Gradually let this physical shifting from one hand to the other become an inner shifting between different features of your own interiority.

13/

Score for a tunnel
(Possible duo)

1) Find a tunnel. This might be a permanent tunnel or a solid temporary one, such as the scaffolding or wooden board tunnels you sometimes see on sidewalks when buildings are under repair.

2) Find a moment when the tunnel is empty. Try out some leaning movements from one side of the tunnel to the other, pushing off each surface. If the space allows for it, have both partners join the movement.

3) Expand this leaning into larger movements. If you see passers-by approaching, close down your movements into small ones until they have exited, when you can open up or expand your movements again.

4) When you are finished, walk away calmly, returning to the open world.

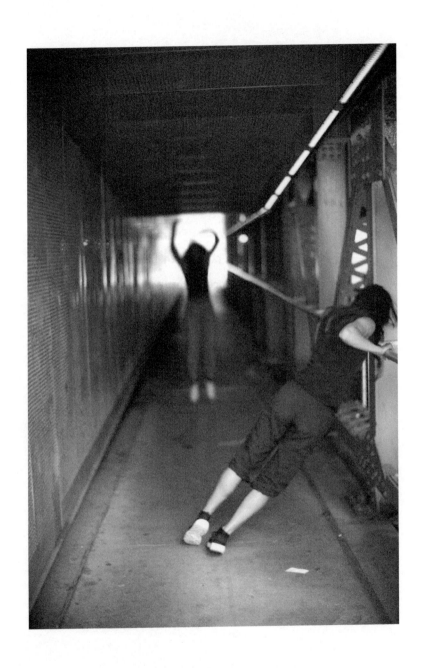

14/

Score for a tall fence

1) Find a tall fence that completely blocks your view.

2) Firmly touch or bounce against each piece of that fence for its whole length. Every now and then find a moment to stop and rest.

3) Switch between relying on the fence as a support and recognizing it as a barrier; lean on it, push into it, and push away from it.

4) Finally, stop, stand back and consider what is beyond the fence.

15/

Score for a dejected tree

1) Find a tree or bush surrounded by concrete or boxed in by buildings, isolated from other greenery and, perhaps, seeming a bit out of place.

2) Stand nearby and consider the sensations of the tree; notice the placement and complexity of its branches.

3) In a minimal way, begin to experiment with small, incremental movements of your shoulders and head as if branches, twigs, or tree limbs are gradually breaking through your skin and extending into space.

4) Tune into any changes you might sense in the tree's isolation.

16/

Score for a public monument

1) Stand near a monument where a public figure (mayor, governor, etc.) might stand for a ceremonial event like Veterans Day or Remembrance Day.

2) First, face the monument. Focus on your inner thoughts, hidden from the public world behind you.

3) Then, slowly turn to focus outwards, knowing that in this moment you are seen as a public figure.

4) Turn back to the monument and return to your private self.

5) Repeat these half turns, each time sensing what changes occur in you in that simple movement.

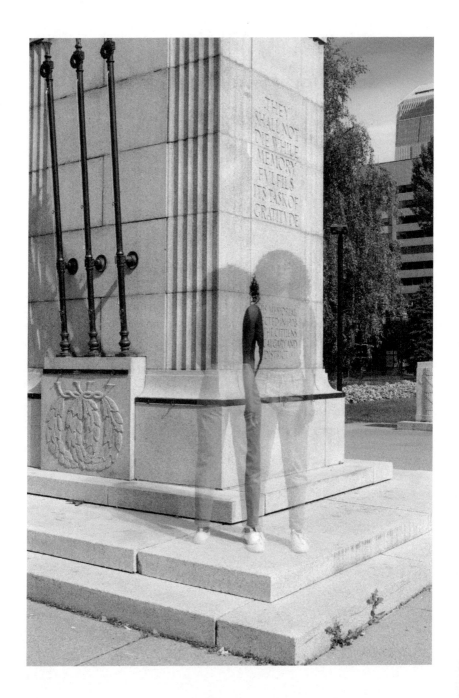

17/

Score for a two-toned ground surface

1) Find a ground surface where two different materials meet, such as limestone and grass, iron and granite, or other such pairing. Be sure that the materials directly border one another and that they can be walked on for some distance.

2) Begin to walk with one foot on each surface.

3) Feel the different support, sound, and give of the different materials. Sense the bifurcation through your body.

18/

Score for the sentinels
(Possible duo)

1) Find a utilitarian structure (or collection of such structures) such as the phone, electricity, or telecommunications boxes that exist on most urban streets.

2) Stand alongside the structure(s), as if facing the direction they are facing. Be perfectly still and fix your gaze on whatever they seem to be looking at. If the space allows, have both partners join the sentinels.

3) Then try one (or more) of the following:

 - Observe any movement that passes across your vision without moving your eyes or head.

 - 'Stand guard' with the objects.

 - Sense the wires that are inside these structures as being inside your own body. Feel how these wires extend out of the soles of your feet and connect to the buildings nearby.

19/

Score for a standalone portal

1) Find a portal that has lost its function, for example, a gate without a fence, a stile with no hedge or a doorway with no wall.

2) Stand at a distance from the standalone portal and address yourself to it. Prepare yourself before approaching it.

3) Then, walk firmly towards it with purpose.

4) Pause at the portal, consider.

5) If it makes sense to do so, and is possible, go through it. Otherwise repeat with an altered purpose.

20/

Score for an ornate leaf

1) Find a shrub or plant that has impressively ornate leaves. Choose one leaf and pay attention to its outline or contours.

2) Stand near it, or hold it close to you, and use your pointer finger (forefinger) to draw its outline in the air or on the palm of your other hand. Focus only on the leaf and take as much time as you need to make every indent and curve as precise as possible.

3) Once you have completed the whole leaf perfectly, draw it again, imagining your whole body as the pen. Offer the drawing to the tree or bush.

21/

Score for an object that is stable but askew

1) Find a tree stump, pillar, wall, or the like that is considerably tilted but still stable.

2) Lay the side of your body along the tilt, keeping your head perfectly in line with your spine (i.e. on the angle of the tilt).

3) Consider what this new angle does to you and the object. Ponder the possibilities of living with a permanently tilted gaze.

22/

Score for a small overgrown space

1) Find an enclosed space – maybe a small shed, a lean-to, or an outbuilding – that is overgrown with ivy, weeds, or some other plant-life, but one that you can still enter safely.

2) Stand inside and imagine yourself as one of the plants invading the space – feel yourself rooting, creeping, swelling, budding and flowering in the space. Curve, carve, and writhe your limbs through the space, revelling in its privacy.

3) Then switch your thoughts to the building; imagine that you are the building being invaded by the plants. Experiment with first resisting the plants and then giving way to them.

4) Finally, be your own biotic self, and merge with the invading flora. Become a multi-being, a cyborg, a fusion of human-building-plant.

23/

Score for a slope with a disappearing view

1) Find a gentle slope, where the view beyond the slope disappears as you approach it.

2) As you cllmb the slope, imagine what you will see when you reach the top. Then, once you are there, consider how your remembered or imagined view compares with the reality you now see.

3) Descend the slope and try again. Repeat, imagining, each time, a new vista.

24/

Score for a pseudo-stage

1) Find a space that is set aside from the usual thoroughfares, but that feels open and even a little presentational or 'framed'. This could be a raised cement surface, an empty space between two buildings, a small plot accentuated by an archway, or a wooden platform.

2) First, stand away from the space and consider it as a sideshow. Imagine another person, another animal, or another thing performing in the space.

3) Then step into the space and, in a very minimal and discreet way, become that 'other' that you were watching.

25/

Score for a long high wall
(possible duo)

1) Find a long wall that you cannot see beyond, preferably one that has some features of interest (tendrils of ivy, bumpy stone, mixed materials, etc.).

2) Stand very close to and facing the wall (preferably with your partner, or even multiple partners in this case). Place your hands on the wall and close your eyes.

3) Journey along the wall very slowly, reading the texture of the wall with your hands. Take your time (this can be done for long periods, even 30 minutes or more), and try to be completely silent during the whole process. If health protocols allow, stay very close to your partner(s) and try to remain in light contact with them.

4) Consider the wall as a very detailed, complicated, maybe secret or coded text.

5) If so inclined, once during your journey, take a few steps away from the wall and open your eyes to consider the wall from this very different perspective. Then return to the wall and continue your close, detailed and silent journey along it.

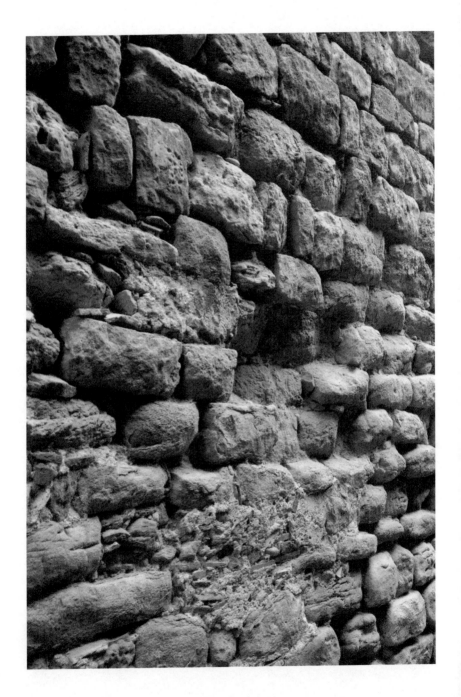

26/

Score for a bifurcated tree

1) Find a relatively slender tree that has a significant fork in its trunk; be sure that the fork is at the height of your chest.

2) Insert your arm into the fork, resting your armpit in the split.

3) Gradually allow yourself to sense your arm separating from the rest of your body.

4) Once you have grasped this sensation, allow your gaze (head) to sneak around the trunk of the tree and confront this new being that was once your arm.

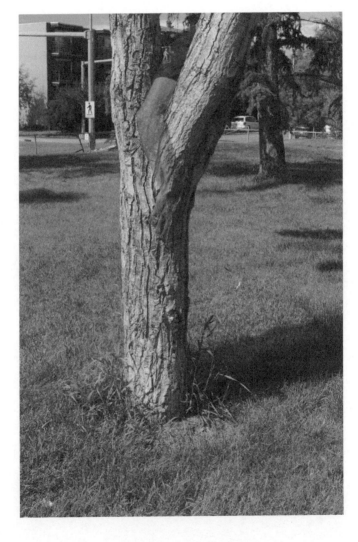

27/

Score for a neglected sculpture garden

1) Find an underused public space with sculptures or sculpturally designed elements like rocks, shaped hedges or standing stones.

2) Relate to these sculptures by either connecting to and extending them with your body or by filling in the negative spaces (open areas) around them.

3) Sense what has changed in the garden as the sculptures enjoy their expanded states.

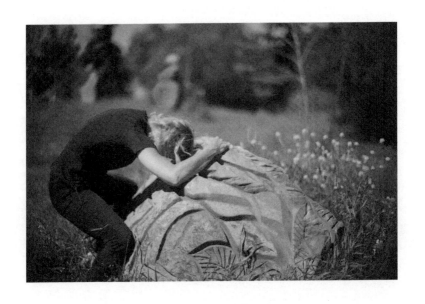

28/

Score for an isolated bench

1) Find a lonely bench that has open space behind it.

2) Stand in front of the bench and prepare to sit down.

3) When ready, sit down. Allow your gaze to be focused straight ahead but direct your attention to the area behind the bench.

4) Sense someone arriving right behind you. Stand with purpose and turn to greet them.

5) Repeat, greeting someone new each time.

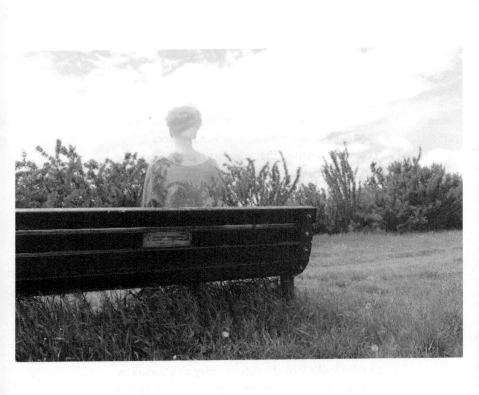

29/

Score for a pathway or line of planters (Possible duo)

1) Find a sequence of objects – planters, ornamental stones, a line of shrubs in a park, sculptures lining a roadway – anything that suggests a path. If possible, choose a sequence with contrasting views at each end, perhaps one with and one without an extensive vista.

2) If the space allows for a duo, position one partner at either end of this pathway, both facing the same direction. Ensure that one person is looking outwards, their gaze extending the line of the pathway, while the other is looking along the pathway towards their partner's back.

3) For the person at the rear, literally and metaphorically watch your partner's back as your partner looks into the future. Imagine yourself as your partner's past supporting their contemplation of what is to come.

4) For the person looking outwards, sense that support from behind you and let it buoy your view into the future.

5) When the partner facing outwards is ready, slowly turn to face the other partner, allowing them to turn outwards and face their own future vista. Feel free to repeat this multiple times and to switch pathway endpoints to share each other's vistas.

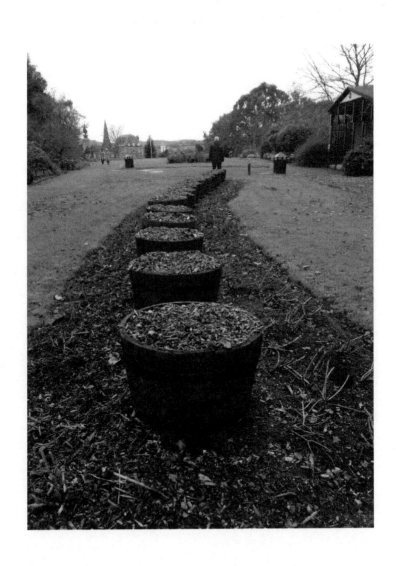

30/

Score for a series of lampposts

1) Find a line of lampposts with space between them.

2) Take your place between two of the posts and look directly downwards.

3) Imagine your face is a light shining on the ground below. Without moving, relate to what you are illuminating.

4) Repeat steps 2 and 3 at multiple spaces between the lampposts, moving to integrate yourself with the varied luminous objects along the way.

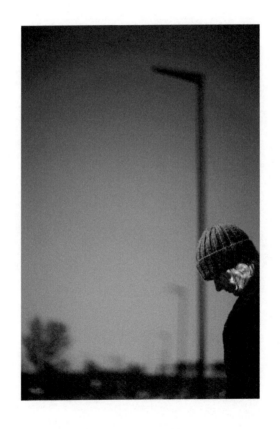

What Bubbles Up

(something to be read <u>after</u> you have tried out the scores)

The Dance of Emergence

If you have been using the scores in a way that feels insightful or beneficial, then you may have begun to discover new zones of freedom in your everyday life – both internal and external. You may have uncovered a love of contemplative physicality; you may have created space for new imaginative adventures. You may have found surprising places, ones that help you resist the relentless invasion and support your journey of emergence.

Once you begin to simply *do* the physical scores without *trying* to conjure anything specific, you may begin to sense more of the hidden work of the raw self, that indescribable or uncategorizable presence before you make any choices, before you have any feeling. You may also start to enjoy the tentative process of emergence, that mysterious meeting place between your

unconscious and conscious selves. And just as the 'trick' with the scores is simply to do them without worrying about what they might signify or communicate, the 'trick' for safeguarding and cultivating your emerging self is to just 'allow'. This is not a psychological enquiry, and certainly not one that promises some quantifiable return or profit. So, allow that process of emergence to transpire in its own way, to move within and around you, just as you move within and around the space. Be (gently) attentive to its unknowability. But do not seek it out. Simply enjoy the moments of closeness with yourself that float to the surface.

If you are fortunate, you may experience a growing space of potentiality, a part of your self where your pre-conscious desires and drives can hover for a while on the brink of your consciousness, where they can work for a little longer, independently and creatively, before tumbling out as plans or ideas or poems or ambitions that you might believe were consciously 'thought up'!

But be gentle and careful. Your dance is not about *showing* something in order for your raw self to show something back. It is a dance of respectful empathy without expectation of reply or profit. It may be hard to accept that anything, particularly something so enigmatic as an emerging self, might have a value in just 'being'. But this is the partner of our inner and outer dance – not necessarily creating or producing or fulfilling anything – but just being with us.

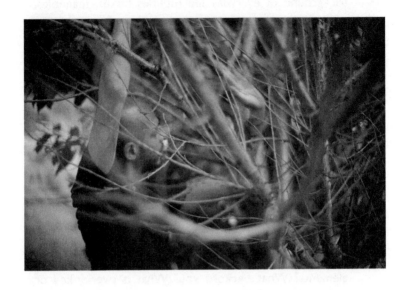

Making Your Own

If the movement meditations we describe here are working for you, your next step might be to create some of your own. They don't have to be complex or detailed; simplicity is often the best recipe!

To create your own score, you will need to find some affordant spaces, attending to their details, including angles, design features, materials and functions. Once you find a spot that seems 'affordant', focus on it, consider *why* it might be disregarded or hidden or enigmatic (or whatever it is that attracted you to it). Ask yourself: what patterns can you see there? Is it geometrical or skewed? Are there missing or broken pieces? Do the objects there complement one another, or do their combinations seem odd? Are there materials that have been repurposed? Have objects that are supposed to be part of the

background of everyday life (utilities boxes, manholes, road signs) assumed heroic or monumental status? Is the appearance of the place at odds with its function? Is there something there that does not jive with its present function or the sense of its past? Does it merge different time periods? Are its sounds and smells incongruent with its apparent status?

As you consider the character and atmosphere of the space, begin to sensitize yourself to it by gradually changing your everyday behaviour. Touch things. Slow down, turn around, take in the space. Increase the intensity of your focus, look for poetry in the accidents of the space. Note what has been eroded or juxtaposed. What first catches your eye? Let your gaze be pulled here and there. Are there amusing, curious, or missing elements? What beckons you? What is overlooked or feels neglected? What materials beg to be examined? How is 'power' written here? Does anything subvert the 'official' narrative of the place?

If possible, discuss these questions with your partner; be open to examining details you may not have noticed yourself. Then try out some small movements that allow for a danced dialogue to develop between you and the place. These movements will be basic, likely including some of the following: standing, turning, sitting, pushing, reaching, bending over, being still, leaning on, touching, holding up, swaying, walking, lying down. You might test different levels (heights) – be safe! – or fill in gaps around objects. You might explore patterns or mimic angles with your body; you might fit yourself into, or work in tension with, different features. Be wary of too much complexity. To begin with, embrace simplicity and let go of thinking too hard about what you are doing; just allow yourself to enjoy the dance of emergence between your raw and conscious selves.

Then, see how these simple movements can constitute a 'score' or set of instructions for movement. Feel free to jot down notes (or not) to remind you of how you moved and to help you tweak the score. Embrace subtlety; see what works without attracting anyone else's attention. Test the *edges* of 'normal behaviour' at the site; experiment with movement that is just *slightly* removed from the typical/acceptable/expected behaviour for that space. And don't be discouraged if some scores don't work, or if some spaces defeat you; they did us.

Depending on your experience of using the scores, you may decide to invite others on your journey. If you choose to share the scores, either the ones here or ones you made yourself, remember that this is all about facilitating a *personal* journey, not imposing your own on someone else. We have learned that there is no point in demonstrating (or performing) the scores for others; our interior meanings are just not accessible by watching. So, to share, others need to learn the process and the scores from text or explanation (not demonstration) and then try them out for themselves. If they enjoy the experience, if they value what happens for them, then you might encourage them to experiment further, potentially making their own scores to pass on to their friends.

Re-engaging with Place

In enacting the scores, you may notice an increasing
engagement with, and awareness of, the world around you.
You may learn unexpected things about the affordance (or
lack thereof) of the public spaces in which you move. You
may uncover surprising stories about your own
neighbourhoods. You may find that the concrete block
that looks like a barrier was once the base for a sculpture
of a mermaid; that the shadowy trees you thought were

sinister are beloved by friends who like to shelter there on hot sunny afternoons; that the aggressive fencing actually allows a population of feral cats to snuggle together and sleep undisturbed by human passers-by. You might notice that in the grey limestone of the High Street bank there are fossils of small plants from the ocean floor millions of years ago; so the bank becomes, for you, an underwater forest to which you can return when you need to find moisture and depth.

Some of this re-engagement may come from moving in the space; a particular kind of surface or an angle of incline may help you uncover a new perspective on the place. Or it may be merely the stillness of lying or standing in a particular place that offers you a heightened experience of the objects and materials around you. You may even notice that those feelings return when you next casually pass by the site. In short, as you make space for the dialogue with your unknowable self, you may also find yourself uncovering the unique, enchanted, peculiar and hidden characters of the everyday spaces around you.

Yet, unlike the experiences you have when dancing with your emerging self, there is no reason to keep your discoveries about places secret. Indeed, sharing them – as part of your friendship with others – may encourage other people to grow curious about affordant spaces, spurring them to try out the movement meditations and uncover their own dialogues between their emerging selves and a biotic world.

We began this handbook by describing the difficult conditions of invasion and manipulation that sparked our discovery of affordant spaces and movement meditations. We cannot be sure how things may change. There are powerful authoritarian forces at work in the world – misogynistic, racist and anti-ecological – that may make life even harder for our hidden selves; forces that may

necessitate an *increasingly* covert way of being; a war (perhaps viral, perhaps virtual) on subjectivity, difference and selfhood that could restrict us to dancing only in home spaces or only with our eyes. On the other hand, a far kinder politics may prevail, so that, more and more, we can find both our inner and outer, our raw and social selves dancing in more and more affordant spaces. We may be able to uncover a greater fullness in our humanity as a part of a world made up not of ordinary or 'uninteresting' spaces, but *extraordinary* places that evoke wonder, delight, and even protection.

Covert is designed to help our exhausted selves recoup, whether for more difficult times ahead or for times that hold open the possibility of liberation. In supporting, nurturing, and cherishing both an inner and hidden dance and an outer and discreet re-engagement with place – despite whatever invasion lies around the corner – we can revel in the fact that, in any circumstance, we have our *emerging selves* as allies.

So, now is the time – fly under the radar, embolden your secret dance in plain sight. Reclaim your emerging self!

References

Barad, Karen (2017) *Meeting the Universe Halfway*. Duke University Press

Bennett, Jane (2010) *Vibrant Matter*. Duke University Press

Berardi, Franco 'Bifo' (2012) *The Uprising: On Poetry and Finance*. Semiotexte

Bown, Alfie (2016) 'Algorithmic Control and the Revolution of Desire'. *ROAR* (4), Winter 2016, pp. 90-99

Cohen, Josh. (2013) *The Private Life: Why We Remain in the Dark*. Granta Books

Kloetzel, Melanie (2017) 'Site and re-site: Early efforts to serialize site dance'. *Dance Research Journal* 49:1 (April) pp. 6-23

_____ (2019a) 'Performing versatility in a neoliberal age: Site-adaptive performance.' *Contemporary Theatre Review* 29:3, pp. 256-274

_____ (2019b) 'Lend me an ear: Dialogism and the vocalizing site', in K. Barbour, V. Hunter and M. Kloetzel (eds), *(Re)Positioning Site Dance: Local acts, global perspectives*, Bristol: Intellect Books, pp. 157-182

Smith, Phil (2014) *Enchanted Things*. Triarchy Press

About the Authors

Phil Smith is a writer, performer and researcher, specialising in walking, site-specificity and mytho-geographies. With Helen Billinghurst he is one half of Crab & Bee, who created the art project 'Plymouth Labyrinth': (plymouthlabyrinth.wordpress.com) and *The Pattern*.

Phil's other publications include *Guidebook for an Armchair Pilgrimage* (2019) with Tony Whitehead and John Schott; *Making Site-Specific Theatre and Performance* (2018); *Walking's New Movement* (2015); and *Mythogeography* (2010).

He is the company dramaturg of TNT Theatre (Munich) and Associate Professor (Reader) at the University of Plymouth.

www.triarchypress.net/smithereens

Melanie Kloetzel (MFA, PhD) is a performance maker, scholar and educator committed to research that spans stage, site, and screen.

Director of the dance theatre company *kloetzel&co.*, and co-director of the art intervention collective *TRAction*, Melanie uses practice-as-research methodologies to develop events and encounters in theatre spaces, alternative venues, spaces of public assembly, and online environments. She is Professor of Dance at the University of Calgary. Her publications can be found in *Dance Research Journal, Contemporary Theatre Review, Choreographic Practices, New Theatre Quarterly,* and the *International Journal of Performance Arts and Digital Media,* among others. Her books, the co-edited anthology *Site Dance: Choreographers and the Lure of Alternative Spaces* (2009) and co-authored *(Re)Positioning Site Dance: Local Acts, Global Perspectives* (2019), are available from University Press of Florida and Intellect.

www.kloetzelandco.com

Also available from Triarchy Press

On Walking... and Stalking Sebald
Phil Smith ~ 2014, 198pp.
"a life-changing beautiful book!" **Avi Allen, Capel y Graig**
Phil describes a walk he made in Suffolk in the footsteps of
W.G. Sebald and sets out his approach to 'conscious walking'.

A Sardine Street Box of Tricks Crab Man & Signpost
(Phil Smith & Simon Persighetti) ~ 2012, 84pp.
*"a terrific resource...a handbook for making a one street 'mis-
guided tour'."* **John Davies**, author of *Walking the M62*

Enchanted Things: Signposts to a New Nomadism
Phil Smith ~ 2014, 98pp.
A photo essay focusing on signs, simulacra, objects and places
that prove to be more, less or other than what they seem.
*"...you'll find our cities and countryside ripe with hidden meanings,
visual puns and unintended contradictions..."* **Gareth E Rees**

Mythogeography: A guide to walking sideways
Phil Smith ~ 2010, 256pp.
The book that started it all *"mocks and subverts traditional
expectations ... in a field where silly concepts are written of with
gaunt severity, Mythogeography might be singled out for its
dedication to chaos."* **Journal of Cultural Geography**

**Counter-Tourism: A Pocketbook: 50 odd things to
do in a heritage site** ~ **Phil Smith** ~ 2012, 84pp.
*"Buy the book! Just think what we could do in Poland with this. I
love Mythogeography. A whole new take on the world. Always
fresh. Great way to shake loose entrenched forms of heritage
tourism."* **Prof. Barbara Kirshenblatt-Gimblett**

Walking's New Movement
Phil Smith ~ 2015, 98pp.
A guide to developments in walking and walk-performance
for enthusiasts, practitioners, students and academics.

Desire Paths
Roy Bayfield ~ 2016, 142pp.
"Roy Bayfield rises from the dead and re-discovers walking as a way of life… a fine mythogeographical grimoire." **Gareth E Rees**

Counter-Tourism: The Handbook
Phil Smith ~ 2012, 228pp.
"…funny and irreverent …Heritage sites and museums would do well to take on some of his ideas, especially those on multiple meaning and injecting fun into visits." **Museums Journal**

Alice's Dérives in Devonshire
Phil Smith ~ Foreword: **Bradley L. Garrett**, 2014, 216pp
A modern fairy tale. *"I have found every possible excuse to creep away and read it… how beautiful, bewildering and breathtaking it is. I don't want it to end…"* **Katie Villa**

Anywhere: A mythogeography of South Devon
Cecile Oak (Phil Smith) ~ 2017, 366pp.
A vivid portrait of a small part of South Devon… An adventure, momentous and fleshy as any novel. It is also the first, detailed mythogeographical survey of a defined area.

The Footbook of Zombie Walking
Phil Smith ~ 2015, 150pp.
Despair, climate change, zombie films, apocalypses, city life, walking & walk-performance… *"a very fine book… I recommend it to everyone with an interest in walking-philosophy"* **Ewan Morrison**

The MK Myth Phil Smith & K ~ 2018, 192pp.
A novel for decaying times set in Milton Keynes.

Rethinking Mythogeography
John Schott & Phil Smith ~ 2018, 52pp.
An illustrated upgrade to the principles & practice of mythogeography. *"…ideas spin in high frequency, creating a shadow walk more vivid than the real one."* **Mary Paterson**

Bonelines
Phil Smith & Tony Whitehead ~ 2020, 362pp.
A dark novel set in Devon's Lovecraft Villages.

Walking Art Practice: Reflections on Socially Engaged Paths
Ernesto Pujol ~ 2018, 160pp.
A text for performative artists, art students and cultural
activists that brings together Pujol's experiences as a monk,
performance artist, social choreographer and educator.

Walking Bodies
eds **Helen Billinghurst, Claire Hind, Phil Smith** ~ 2020, 340pp.
Papers, provocations and actions from the 'Walking's New
Movements' conference (University of Plymouth, Nov.2019)

Guidebook for an Armchair Pilgrimage
John Schott, Phil Smith, Tony Whitehead 2019, 144pp.
*"It is wonderful - a brilliant idea, beautifully done, with a sweetly
companionable tone to the writing."* **Jay Griffiths**

The Pattern: a fictioning
Helen Billinghurst & Phil Smith (Crab & Bee) ~2020, 208pp.
A handbook for exploration, embodiment and art making.
Describes the secrets of 'web-walking'.

The Architect-Walker
Wrights & Sites ~ 2018, 120pp.
An anti-manifesto for changing a world while exploring it.

Walking Stumbling Limping Falling: A Conversation
Alyson Hallett & Phil Smith ~ 2017, 104pp.
An email conversation between the authors about being
prevented from walking 'normally' by illness.

Ways to Wander
eds. **Claire Hind & Clare Qualmann** ~ 2015, 80pp.
54 intriguing ideas for different ways to take a walk - for
enthusiasts, practitioners, students and academics.

Ways to Wander the Gallery
eds. **Claire Hind & Clare Qualmann** ~ 2018, 80pp.
25 ideas for ways to walk in and beyond an art gallery.

www.triarchypress.net